IF
PERSONAL EXPERIENCE
CAN REFLECT ITSELF,
I THINK WRITING IS
A KIND OF FRAGMENT OF SELF.

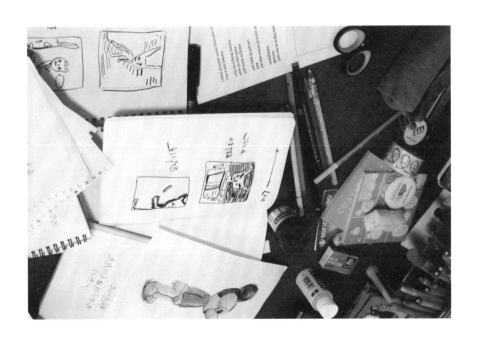

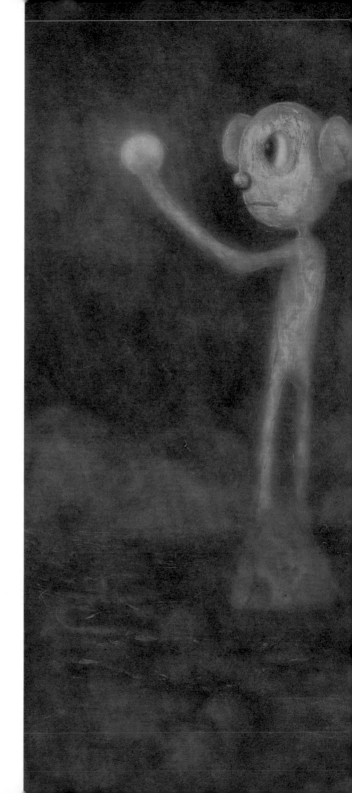

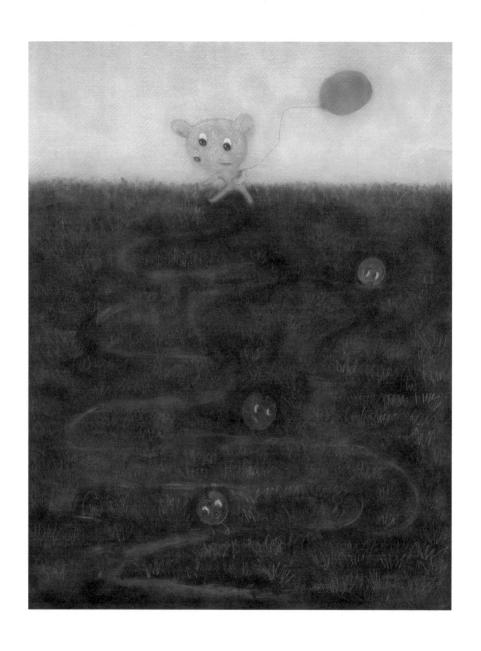

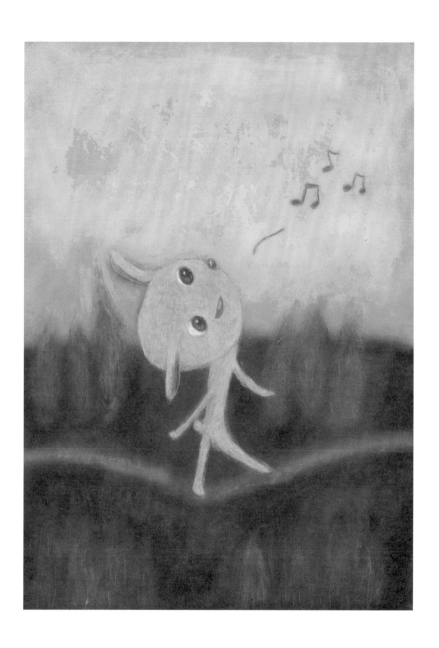

③

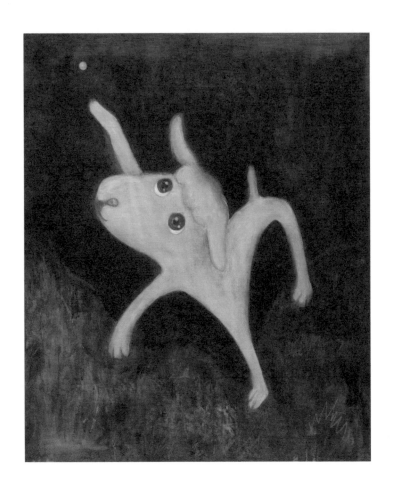

④

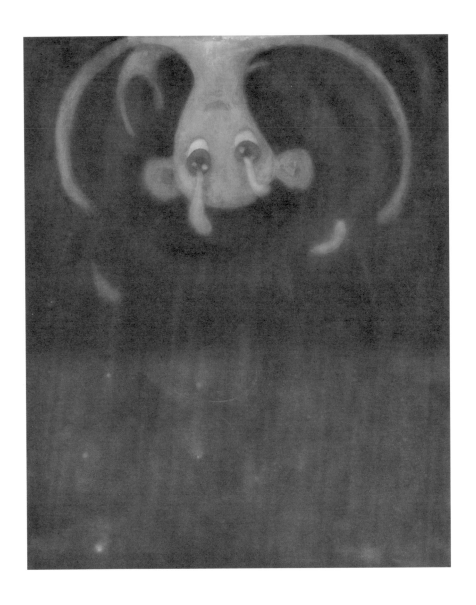

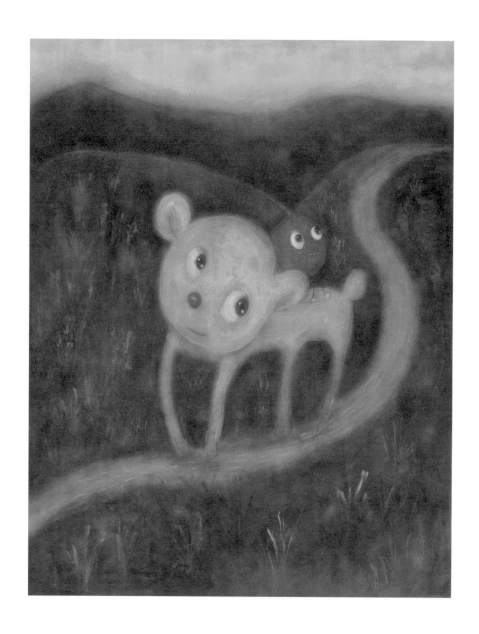

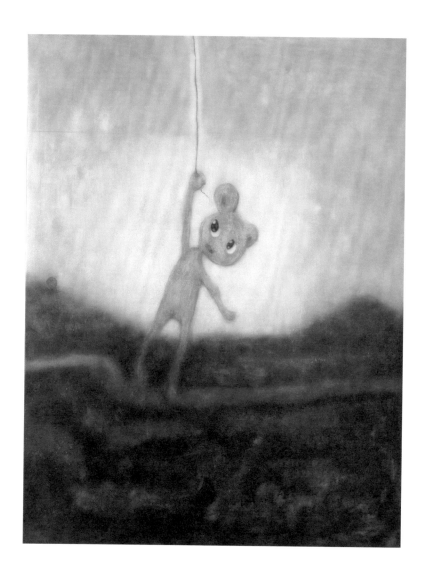

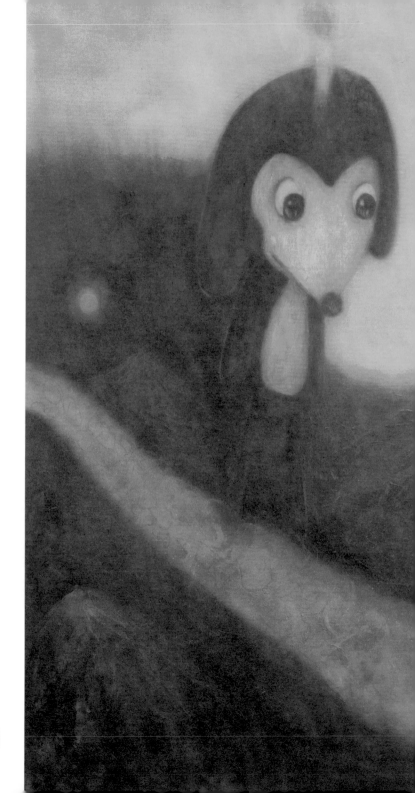

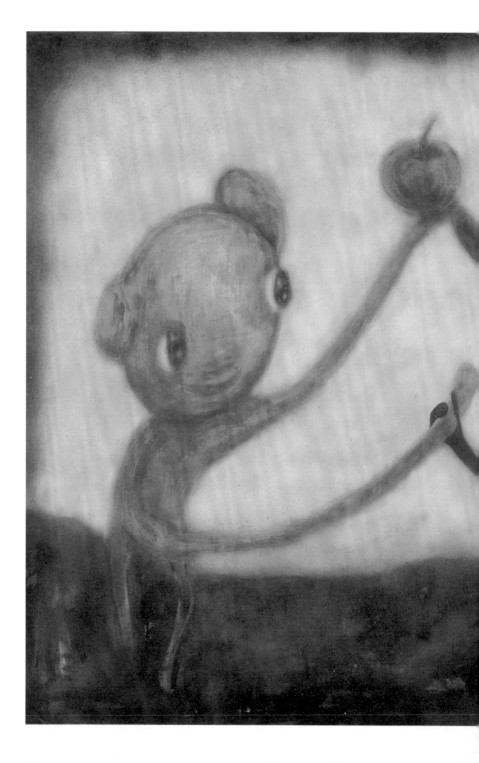

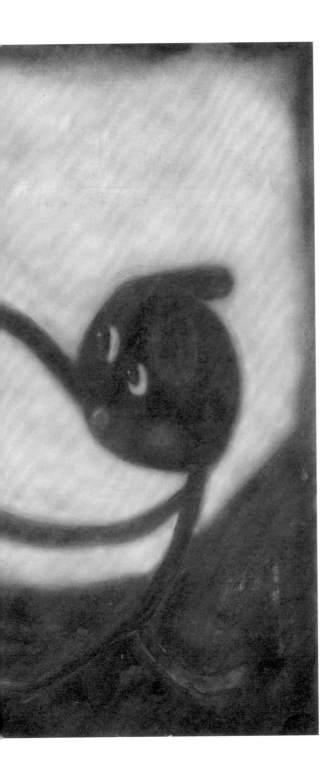

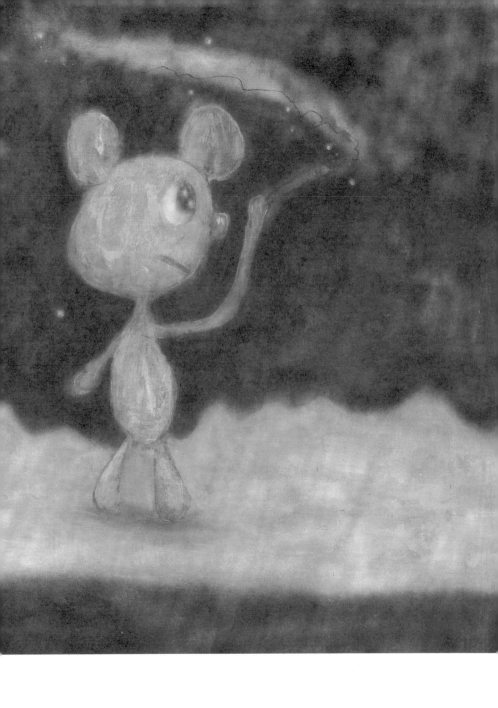

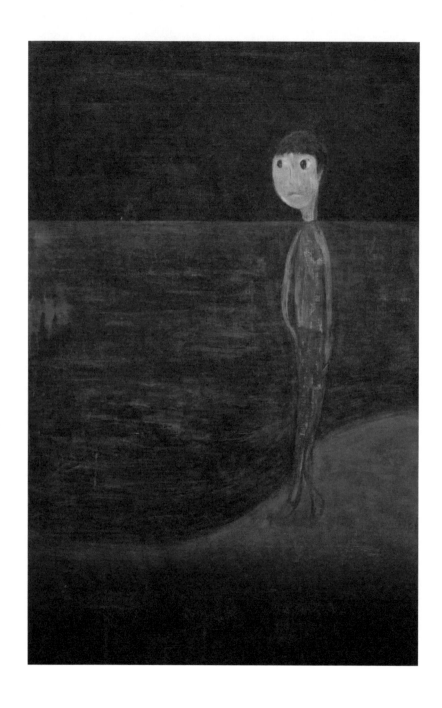

⑪

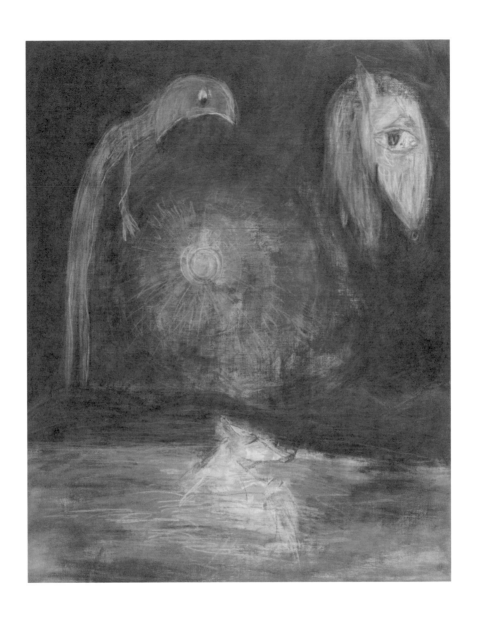

12

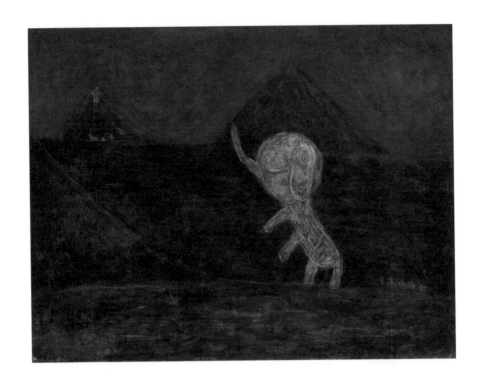

⑬

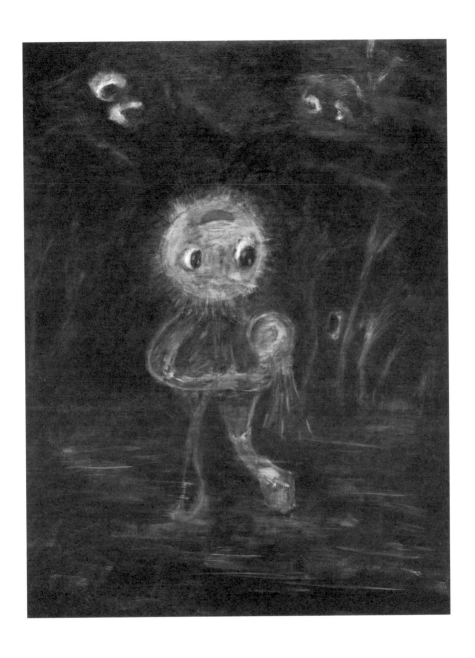

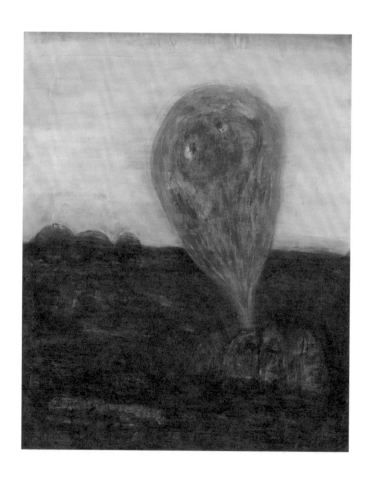

⑮

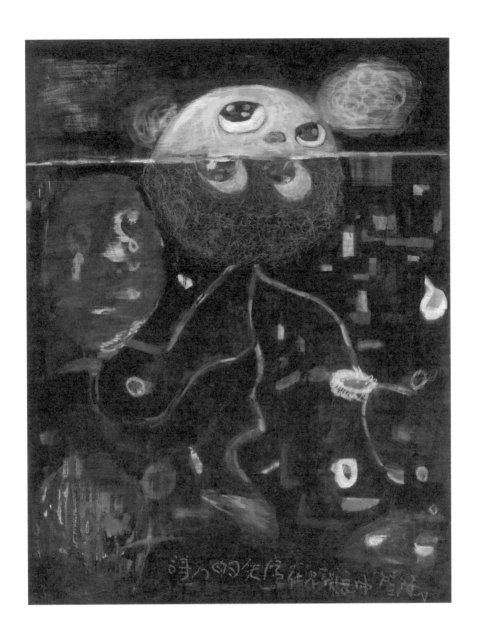

得力的失陷在花開之時智慧

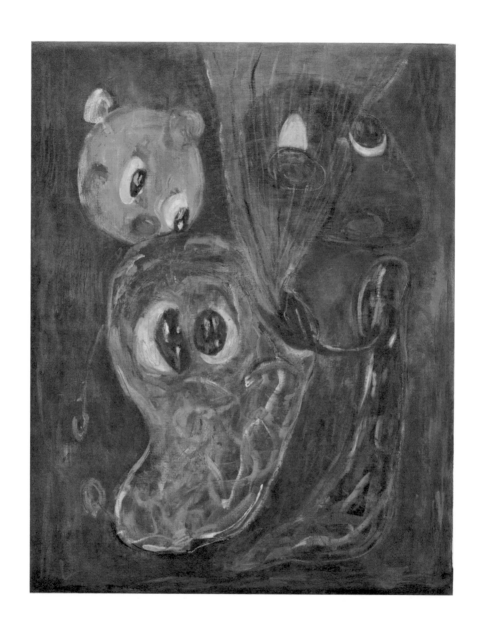

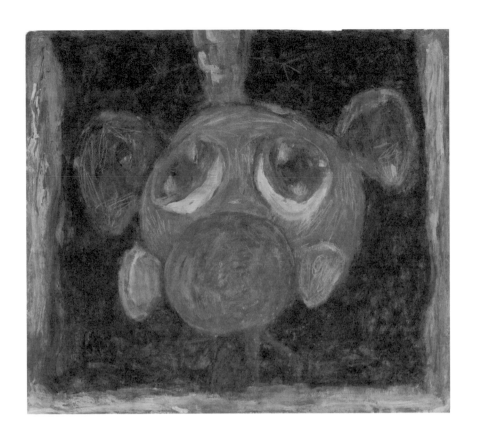

⑱

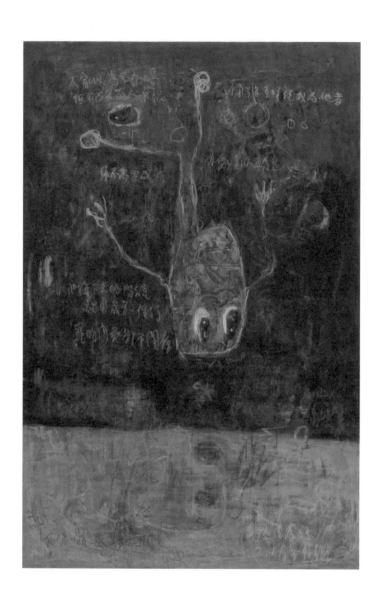

⑲

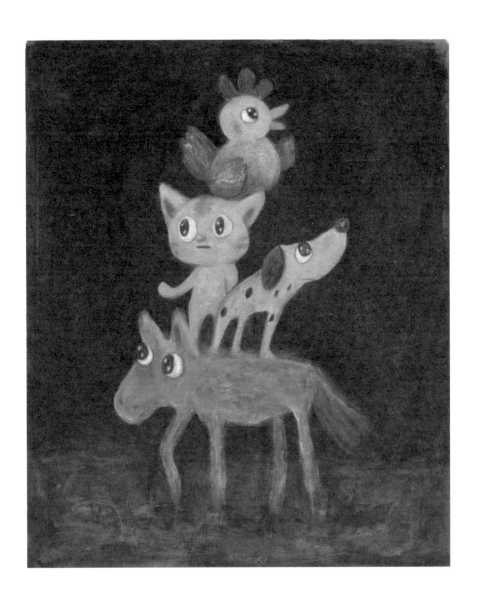

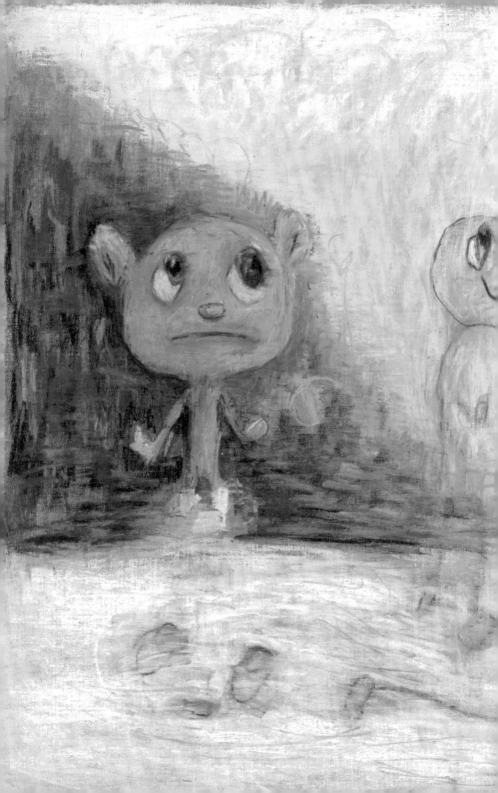

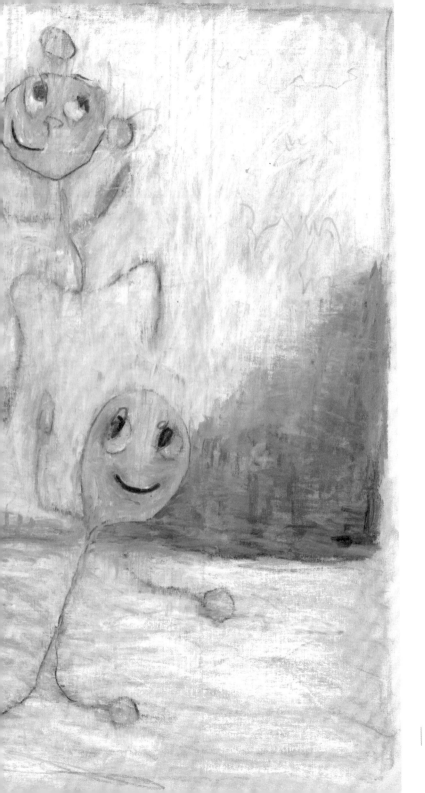

27

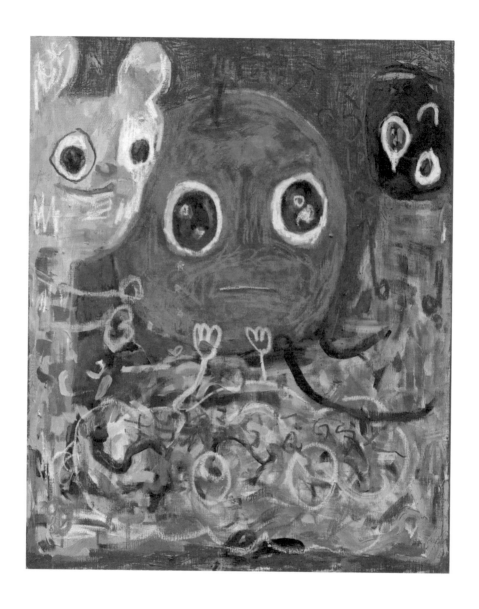

less㉒

less28

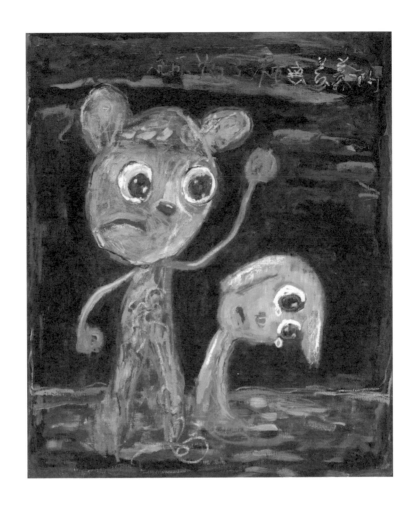

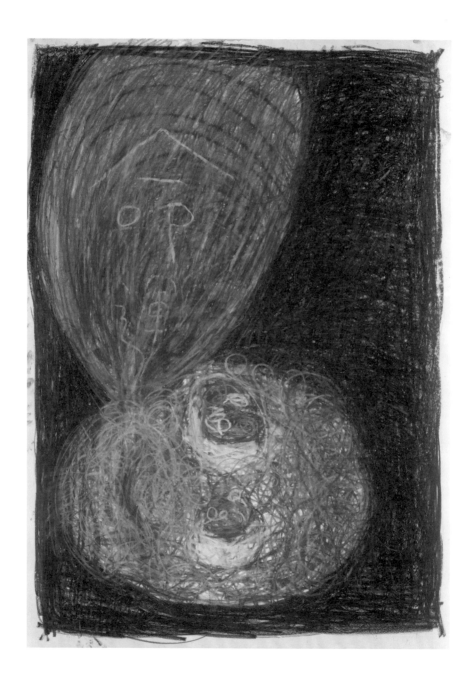

(24)

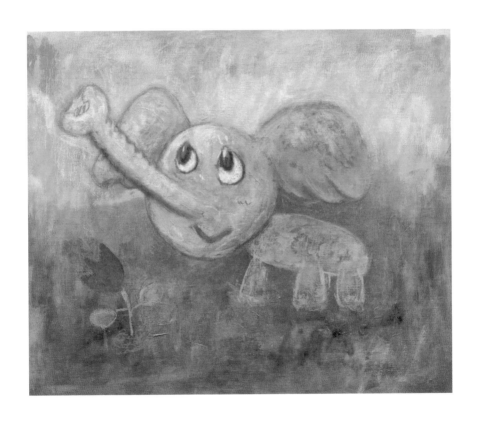

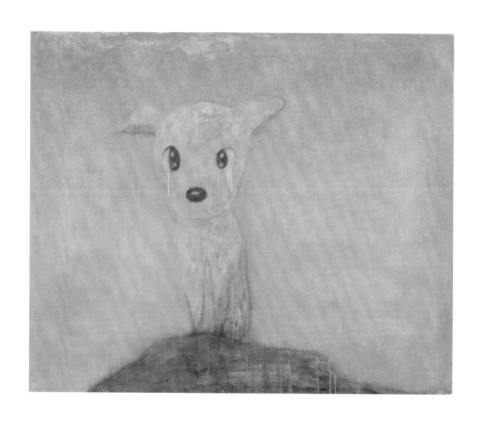

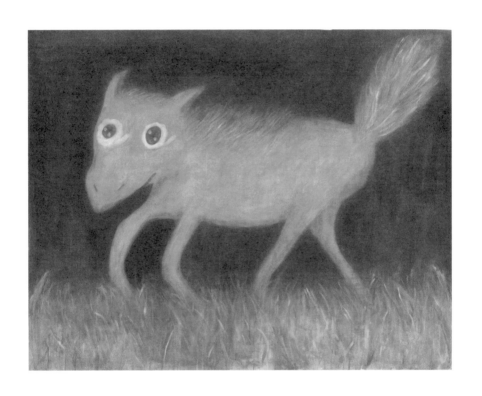

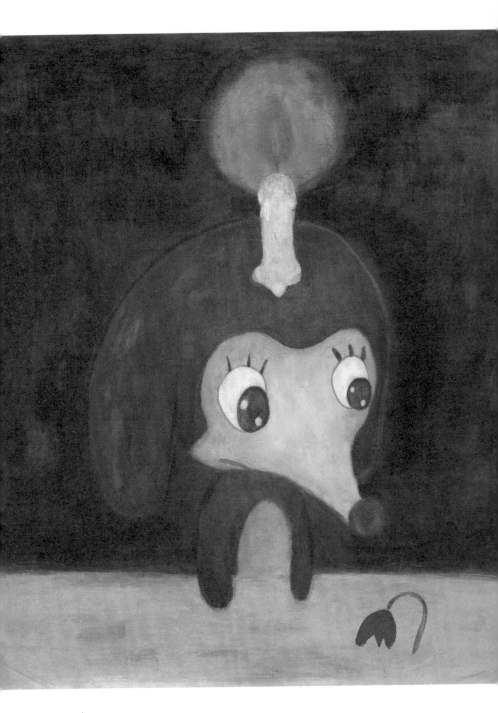

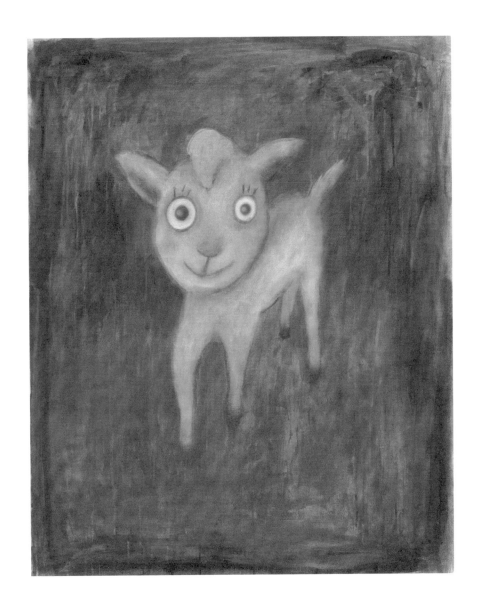

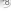

35

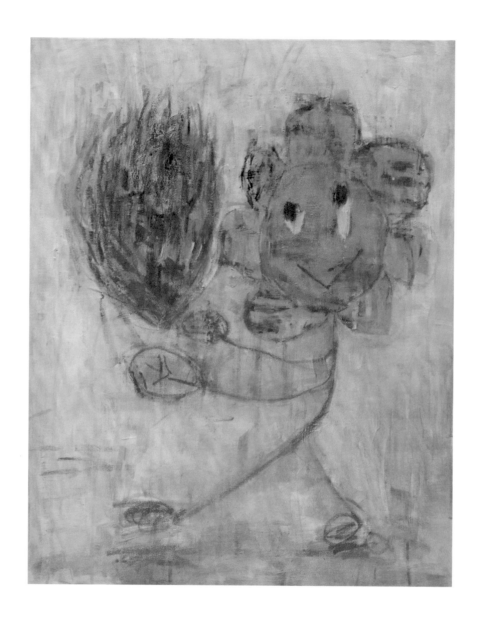

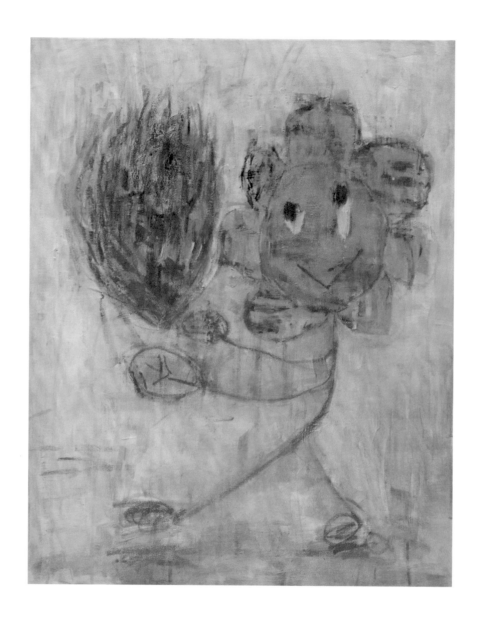

30

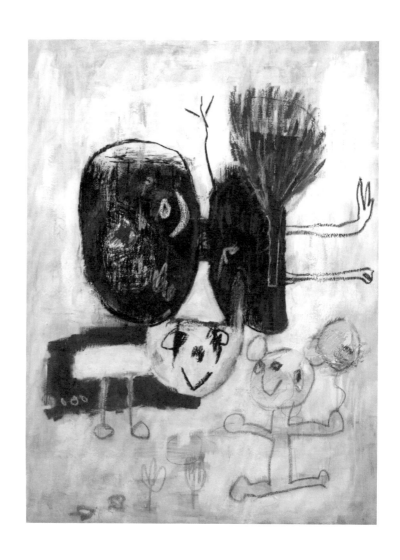

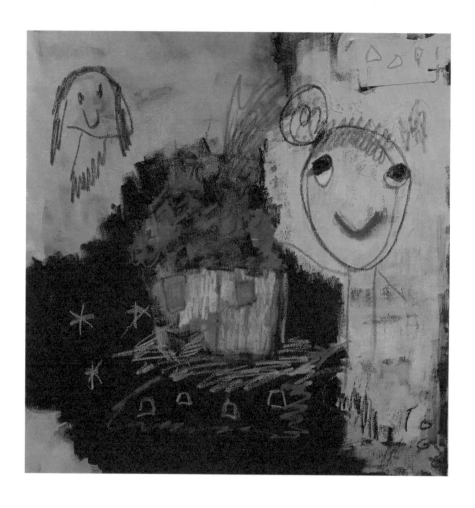

32

33

38

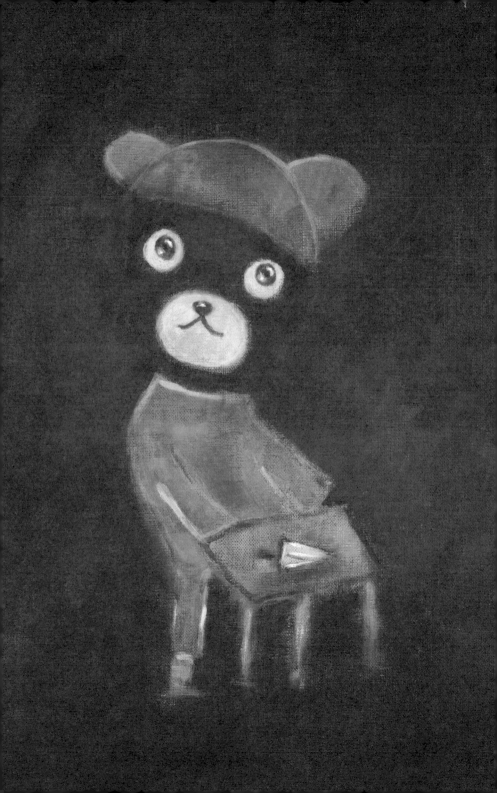

Writing Person | CHEN WEI TING

Cover work | **Lonely room with you**, 2023, acrylic, oil pastel and colored pencil on canvas, 108x89cm / **1** **We still searching for truth but...** , 2023, acrylic, oil pastel and colored pencil on canvas, 172x201.5cm / **2** **Maze**, 2023, acrylic, oil pastel and colored pencil on canvas, 154.5x121cm / **3** **Chaos and peace**, 2023, acrylic, oil pastel and colored pencil on canvas, 87x62.5 cm / **4** **It's just an illusion**, 2023, acrylic, oil pastel and colored pencil on canvas, 88x74cm / **5** **Everything is just a passing shower**, 2023, acrylic, oil pastel and colored pencil on canvas, 141x170cm / **6** **Take me home**, 2023, acrylic, oil pastel and colored pencil on canvas,153x121.5cm / **7** **I will follow you into somewhere**, 2023, acrylic, oil pastel and colored pencil on canvas, 115.4 x 148.4 cm / **8** **Each has its own subject**, 2023, acrylic, oil pastel and colored pencil on canvas, 201x171cm / **9** **Promise**, 2023, acrylic, oil pastel and colored pencil on canvas,153x121.5cm / **10** **Who knows the Tao**, 2023, acrylic, oil pastel and colored pencil on canvas, 202x139.5cm / **11** **Manjusaka**, 2022, acrylic, oil pastel and colored pencil on canvas, 100 x 65 cm / **12** **Goodnight my Sunshine**, 2022, Acrylic, colored pencil on canvas, 81 x 66 cm / **13** **One elephant walking toward another**, 2022, acrylic, oil pastel and colored pencil on canvas, 137x104cm / **14** **The sun that stole the moon**, 2022 acrylic, oil pastel on canvas 145 x 122 cm / **15** **Pink Desire**, 2022, acrylic, oil pastel and colored pencil on canvas, 80x99cm / **16** **There is an another me in the ocean**, 2022, acrylic, oil pastel and colored pencil on canvas, 80x100cm / **17** **He found a box in my back**, 2022, acrylic, oil pastel and colored pencil on canvas, 82x100cm / **18** **Face myself in the black ocean**, 2022, acrylic, oil pastel and colored pencil on canvas, 64x56cm / **19** **Falling and see yourself**, 2022, acrylic, oil pastel and colored pencil on canvas, 194x130cm / **20** **The Bremen Band- together**, 2022, acrylic and colored pencil on canvas, 88x106cm / **21** **Paradise**, 2022, oil pastel on canvas, 121x153cm / **22** **Share an apple**, 2021, acrylic, oil pastel on canvas,72.5x60.5cm / **23** **Nobody cares your soul**, 2021, acrylic, colored pencil, oil pastels on canvas, 72x84cm / **24** **The fire of life**, 2021, oil pastel on paper, 108x79cm / **25** **Elephant**, 2019, acrylic, oil pastel, colored pencil on canvas, 65x53cm / **26** **Who will stay**, 2020, acrylic, colored pencil on canvas, 122x156cm / **27** **Go through with darkness**, 2020, acrylic, colored pencil on canvas, 122x156cm / **28** **One day I will gone with an ocean**, 2019, acrylic, colored pencil on canvas, 81x68cm / **29** **Little Goat**, 2019, acrylic, colored pencil on canvas, 90.5x72cm / **30** **You'll See**, 2018, acrylic, oil pastel, colored pencil on canvas, 65x53cm / **31** **Falling and Blooming**, 2017, acrylic, oil pastel, colored pencil on canvas, 80x60.5cm / **32** **Yours and Mine**, 2017, acrylic, oil pastel, colored pencil on canvas, 65x65cm / **33** **Without Body**, 2015, acrylic, colored pencil on canvas, 45x38.5cm

All Art Works | Chen Wei Ting
Edit | Chen Wei Ting
Design | Chun Ta Chu

ISBN | *978-626-01-1424-4 (* 平裝 *)*

| First Edition |

Website | www.chenwts.com *Instagram* | Chenweiting_art *Facebook* | Chenwts